Outdoor Sketching

Outdoor Sketching

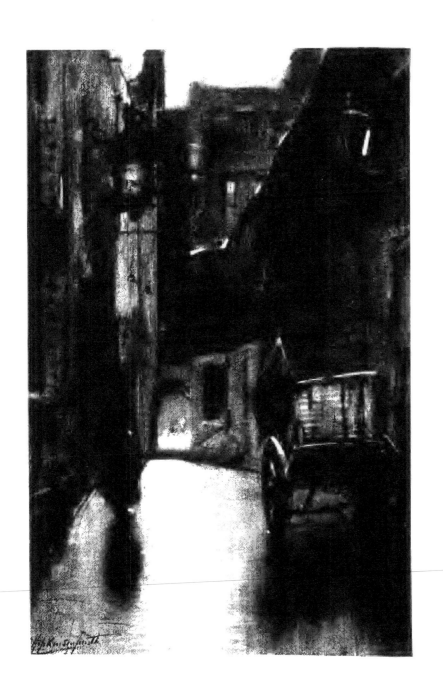

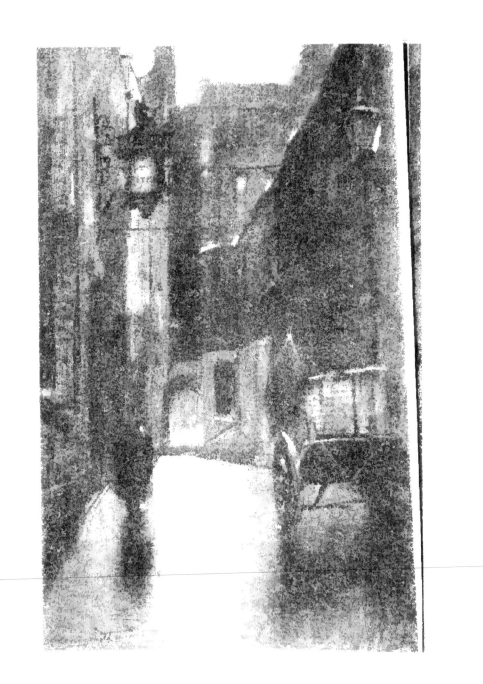

Outdoor Sketching

Four Talks Given Before
The Art Institute of Chicago

The Scammon Lectures, 1914

By

F. Hopkinson Smith

With Illustrations by
the Author

New York
Charles Scribner's Sons
1915
A

Contents

Illustrations

COMPOSITION

COMPOSITION

MY chief reason for confining these four talks to the outdoor sketch is because I have been an outdoor painter since I was sixteen years of age; have never in my whole life painted what is known as a studio picture evolved from memory or from my inner consciousness, or from any one of my outdoor sketches. My pictures are begun and finished often at one sitting, never more than three sittings; and a white umbrella and a three-legged stool are the sum of my studio appointments.

Another reason is that, outside of this ability to paint rapidly out-of-doors, I know so little of the many processes attendant upon the art of the painter that both my advice and my criticism would be worthless to even the young-

3

est of the painters to-day. Again, I work only in two mediums, water-color and charcoal. Oil I have not touched for many years, and then only for a short time when a student under Swain Gifford (and this, of course, many, many years ago), who taught me the use and value of the opaque pigment, which helped me greatly in my own use of opaque water-color in connection with transparent color and which was my sole reason for seeking the help of his master hand.

A further venture is to kindle in your hearts a greater love for and appreciation of what a superbly felt and exactly rendered outdoor sketch stands for—a greater respect for its vitality, its life-spark; the way it breathes back at you, under a touch made unconsciously, because you saw it, recorded it, and then forgot it—best of all because you let it alone; my fervent wish being to transmit to you some of the enthusiasm that has kept me

4

young all these years of my life; something of
the joy of the close intimacy I have held with
nature—the intimacy of two old friends who
talk their secrets over each with the other; a
joy unequalled by any other in my life's expe-
rience.

There may be those who go a-fishing and
enjoy it. The arranging and selecting of flies,
the jointing of rods, the prospective comfort
in high water-boots, the creel with the leather
strap, every crease in it a reminder of some
day without care or fret—all this may bring
the flush to the cheek and the eager kindling
of the eye, and a certain sort of rest and hap-
piness may come with it; but—they have
never gone a-sketching! Hauled up on the
wet bank in the long grass is your boat, with
the frayed end of the painter tied around some
willow that offers a helping root. Within a
stone's throw, under a great branching of
gnarled trees, is a nook where the curious sun,

peeping at you through the interlaced leaves, will stencil Japanese shadows on your white umbrella. Then the trap is unstrapped, the stool opened, the easel put up, and you set your palette. The critical eye with which you look over your brush-case and the care with which you try each feather point upon your thumb-nail are but an index of your enjoyment.

Now you are ready. You loosen your cravat, hang your coat to some rustic peg in the creviced bark of the tree behind, seize a bit of charcoal from your bag, sweep your eye around, and dash in a few guiding strokes. Above is a changing sky filled with crisp white clouds; behind you, the great trunks of the many-branched willows; and away off, under the hot sun, the yellow-green of the wasted pasture, dotted with patches of rock and weeds, and hemmed in by the low hills that slope to the curving stream.

It is high noon! There is a stillness in the

air that impresses you, broken only by the low murmur of the brook behind and the ceaseless song of the grasshopper among the weeds in front. A tired bumblebee hums past, rolls lazily over a clover blossom at your feet, and has his midday lunch. Under the maples near the river's bend stand a group of horses, their heads touching. In the brook below are the patient cattle, with patches of sunlight gilding and bronzing their backs and sides. Every now and then a breath of cool air starts out from some shaded retreat, plays around your forehead, and passes on. All nature rests. It is her noontime.

But you work on: an enthusiasm has taken possession of you; the paints mix too slowly; you use your thumb, smearing and blending with a bit of rag—anything for the effect. One moment you are glued to your seat, your eyes riveted on your canvas; the next, you are up and backing away, taking it in as a whole,

then pouncing down upon it quickly, belaboring it with your brush. Soon the trees take shape; the sky forms become definite; the meadow lies flat and loses itself in the fringe of willows.

When all of this begins to grow upon your once blank canvas, and some lucky pat matches the exact tone of blue-gray haze or shimmer of leaf, or some accidental blending of color delights you with its truth, a tingling goes down your backbone, and a rush surges through your veins that stirs you as nothing else in your whole life will ever do. The reaction comes the next day when, in the cold light of your studio, you see how far short you have come and how crude and false is your best touch compared with the glory of the landscape in your mind and heart. But the thrill that it gave you will linger forever!

Or come with me to Constantinople and let us study its palaces and mosques, its marvel-

Composition

lous stuffs, its romantic history, its religions—
most profound and impressive—its commerce,
industries, and customs. Come to revel in
color; to sit for hours, following with reverent
pencil the details of an architecture unrivalled
on the globe; to watch the sun scale the hills
of Scutari and shatter its lances against the
fairy minarets of Stamboul; to catch the swing
and plash of the rowers rounding their *caiques*
by the bridge of Galata; to wander through
bazaar and market, dotting down splashes of
robe, turban, and sash; to rest for hours in
cool tiled mosques, which in their very decay
are sublime; to study a people whose rags are
symphonies of color, and whose traditions and
records breathe the sweetest poems of modern
times.

And then, when we have caught our breath,
let us wander into any one of the patios along
the Golden Horn, and feast our eyes on col-
umns of verd-antique, supporting arches light

9

as rainbows, framing the patio of the Pigeon Mosque, the loveliest of all the patios I know, and let us run our eyes around that Moorish square. The sun blazes down on glistening marbles; gnarled old cedars twist themselves upward against the sky; flocks of pigeons whirl and swoop and fall in showers on cornice, roof, and dome; tall minarets like shafts of light shoot up into the blue. Scattered over the uneven pavement, patched with strips and squares of shadows, lounge groups of priests in bewildering robes of mauve, corn-yellow, white, and sea-green; while back beneath the cool arches bunches of natives listlessly pursue their several avocations.

It is a sight that brings the blood with a rush to one's cheek. That swarthy Mussulman at his little square table mending seals; that fellow next him selling herbs, sprawled out on the marble floor, too lazy to crawl away from the slant of sunshine slipping through the ragged

awning; that young Turk in frayed and soiled embroidered jacket, holding up strings of beads to the priests passing in and out—is not this the East, the land of our dreams? And the old public scribe with the gray beard and white turban, writing letters, the motionless veiled figures squatting around him—is he not Baba Mustapha? and the soft-eyed girl whispering into his ear none other than Morgiana, fair as the meridian sun?

So, too, in my beloved Venice, where many years ago I camped out by the side of a canal —the Rio Giuseppe—all of it, from the red wall, where the sailors land, to the lagoon, where the tower of Castello is ready to topple into the sea.

Not much of a canal—not much of a painting ground, really, to the masters who have gone before and are still at work, but a truly lovable, lovely, and most enchanting possession to me their humble disciple. Once you get into it you never want to get out, and once

out you are miserable until you get back again. On one bank stretches a row of rookeries— a maze of hanging clothes, fish-nets, balconies hooded by awnings and topped by nonde- script chimneys of all sizes and patterns, with here and there a dab of vermilion and light red, the whole brilliant against a china-blue sky. On the other is the long brick wall of the garden—soggy, begrimed, streaked with moss and lichen in bands of black-green and yellow ochre, over which mass and sway the great sycamores that Ziem loved, their lower branches interwoven with cinnobar cedars gleaming in spots where the prying sun drips gold.

Only wide enough for a barca and two gon- dolas to pass—this canal of mine; only deep enough to let a wine barge slip through; so nar- row you must go all the way back to the lagoon if you would turn your gondola; so short you can row through it in five minutes; every inch

of its water-surface part of everything about
it, so clear are the reflections; full of moods,
whims, and fancies, this wave space—one mo-
ment in a broad laugh coquetting with a bit
of blue sky peeping from behind a cloud, its
cheeks dimpled with sly undercurrents, the
next swept by flurries of little winds, soft as
the breath of a child on a mirror; then, when
aroused by a passing boat, breaking out into
ribbons of color—swirls of twisted doorways,
flags, awnings, flower-laden balconies, black-
shawled Venetian beauties all upside down,
interwoven with strips of turquoise sky and
green waters—a bewildering, intoxicating jum-
ble of tatters and tangles, maddening in detail,
brilliant in color, harmonious in tone: the
whole scintillating with a picturesqueness be-
yond the ken or brush of any painter living or
dead.

These are some of the joys of the painter
whose north light is the sky, whose studio door

is never shut, and who often works surrounded by envious throngs, that treat him with such marked reverence that they whisper one to another for fear of disturbing him.

And now for a few practical hints born of these experiences; and in giving them to you, remember that no man is more keenly conscious of his limitations than the speaker. My own system of work, all of which will be explained to you in subsequent talks, one on water-color and the other on charcoal, is, I am aware, peculiar, and has many drawbacks and many shortcomings. I make bold to give these to you because of my fifty years' experience in outdoor sketching, and because in so doing I may encourage some one among you to begin where I have left off and do better. The requirements are thoughtful and well-studied selection before your brush touches your canvas; a correct knowledge of composition; a definite grasp

of the problem of light and dark, or, in other words, *mass;* a free, sure, and untrammelled rapidity of execution; and, last and by no means least, a realization of what I shall express in one short compact sentence, that *it takes two men to paint an outdoor picture: one to do the work and the other to kill him when he has done enough.*

Before entering on the means and methods through which so early a death becomes permissible I shall admit that the personal equation will largely assert itself, and that because of it certain allowances must be made, or rather certain variations in both grasp and treatment will necessarily follow.

While, of course, nature is always the same, never changing and never subservient to the whims or perceptive powers of the individual, there are painters who will aver that they alone see her correctly and that all the world that

differs from them is wrong. One man from natural defects may see all her greens or reds stronger or weaker than another in proportion to the condition of his eye. Another may grasp only her varying degrees of gray. One man unduly exaggerates the intensity of the dark and the opposing brilliancy of the lights. Another eye—for it is largely a question of optics, of optics and temperament—sees only the more gentle and sometimes the more subtle gradations of light and shade reducing even the blaze of the noonday sun to half-tones. Still another, whether by the fault of over-magnifying power or long-sightedness, detects an infinity of detail in nature, and is not satisfied until each particular blade of grass stands on end like the quills of the traditional porcupine, while his brother brush strenuously asserts that every detail is really only a question of mass, and should be treated as such, and that for all practical purposes it is quite immaterial whether

a tree can be distinguished from a farm-house so long as it is fluffy enough to be indistinct.

These defects, sympathies, tendencies, whatever one may call them, only prove the more conclusively that there are many varying standards set up by many minds. That which can easily be proved in addition is that many a false standard owes its origin as often to a question of bad digestion as of bad taste. They also show us that no one man or set of men can rightfully lay claim to holding the one key which unlocks the mysteries of nature, while insisting that the rules governing their use of that key *must* be adhered to by the rest of the world.

There are, however, certain laws which control every pictured expression of nature and to which every eye and hand must submit if even a semblance of expression is to be sought for. One of them is truth. In this all schools concur, each one demanding the truth, or at least enough of it to placate their consciences

when they add to it a sufficient number of lies of their own manufacture to make the subject interesting to their special line of constituents. Among these I do not class the lunatics who are to-day wandering loose outside of charitable asylums especially designed for disordered and impaired intellects, and whose frothings I saw at the last Autumn Salon.

But to our text once more, taking up the first requirement; namely, selection.

By selection I mean the "cutting out entire" from the great panorama spread out before you just that portion which appeals to you and which you want to have appeal to your fellow men.

Speaking for myself, I have always held that the most perfect reproductions of nature are those which can be *selected* any day, under any condition of light, direct from the several objects themselves, without arrangement and foreshortenings or twistings to the right and to

the left. Nothing, in fact, seems to me so astounding as that any human mind could for an instant suppose that it can improve on the work of the Almighty.

If it is a street, and if you wish to express its perspective, and the bit of blue sky beyond, with a burst of sunlight illumining the corner, the figures crowded against the light, forming a mass in themselves, and it interests you at a glance, sit down and study it long enough to find out what feature of the landscape impressed you at *first sight*. If, as you look, the first impression becomes weakened, perhaps it is because the immediate foreground, which at the first glance was clear, is now dotted with passers-by, thus obscuring your point of interest, or a cloud has passed over the sky, lowering the whole tone, or the group of figures across the light has dispersed, exposing the ugly right-angled triangle of the flat wall and street level instead of the same lines being

broken picturesquely with the black dots of heads of the crowd itself. In a moment it is no longer a composition of the same power that struck you at first. Perhaps while you sit and wait the scene again changes, and something infinitely more interesting, or the reverse, is evolved from the perspective before you. And so it goes on, until this constantly changing kaleidoscope repeats itself in its first aspect, until you have fairly grasped its meaning and analyzed its component parts. Or until either the effect that first delighted you, or the subsequent effect that charmed you still more, becomes a fixed fact in your mind. That, then, is the picture that you want to paint and that you are to paint *exactly as you saw it*. And if you can reproduce it exactly as you did see it, ten chances to one it will impress your fellow men. The trouble is that when you sit down to paint it you are so often lost in its detail that you forget its salient features, and by the time

you have finished and blocked up the immediate foreground with figures that did not exist when you were first thrilled by its beauty, you have either painted its least interesting aspect, or you have filled that street so full of lies of your own that the policeman on the beat could not recognize it.

Of course, while all nature is interesting, there are parts of nature more interesting than other parts, and since the skill of man is inadequate to produce its more *humble* effects, if I may so express it, the painter should be on the lookout for her *dramatic* air, in order that when she is reproduced she may add that touch to her many qualities, thus meeting the painter half-way. Even in the perspective of a street, nature, in profound consideration of the devotee under his umbrella, often gives him a deeper touch—one wall perhaps in sudden brilliant light, while the vista of the street is in gloom made by a passing cloud, she constantly calling

out to the painter as he works: "Watch me now and take me at my best."

Or change this picture for an instant and note, if you please, the flight of cloud shadows over a mountain slope or the whirl of a wind flurry across a still lake. There are moments in all phenomena like these where a great man rising to the occasion can catch them exactly, as did Rousseau in the golden glow of the fading light through the forest, or Corot in the crisp light of the morning, or Daubigny in the low twilight across the sunken marshes where one can almost hear the frogs croak.

Selection, then, preceded by the deepest and closest thought as to whether the subject is worth painting at all, becomes necessary, the student giving himself plenty of time to study it in all its phases; time enough to "walk around it," reviewing it at different angles; noting the hour at which it is at its best and happiest, seizing upon its most telling present-

ment—and all this before he begins even *mentally* to compose its salient features on the square of his canvas. You can turn, if you choose, your camera skyward and focus the top of a steeple and only that. It is true, but it is uninteresting, or rather unintelligible, until you focus also the church door, and the gathering groups, and the overgrown pathway that winds through the quiet graveyard. So a picture can be true and yet very much like a slip cut from a newspaper. For some men cut thus into nature, haphazard, without care or thought, and produce perhaps a square containing an advertisement of a patent churn, a railroad timetable, and a fragment of an essay on art. Cut carefully and with selection, and you may get a poem which will soothe you like a melody.

As to the value of the laws which govern the perfect composition, it is unquestionably true that a correct knowledge of these laws

makes or unmakes the picture and establishes
or ruins the rank of the painter. No matter
how careful the drawing, how interesting the
subject, how true the mass, how subtle the
gradations of light and shade, how perfect the
expression of the figures, or how transparent
the atmosphere of a landscape, a want of
this knowledge will defeat the result. On the
other hand, a good composition—one that
"carries," as the term is—one that can be seen
across the room, if properly composed will in-
stantly excite your interest, even if upon near
inspection you are shocked by its crudities and
faults. "I don't know what it is," says a
painter, "but it's good all the same."

After your selection has been made, the next
thing is to search for its centre of interest.
When this is found it is equally important to
weigh carefully the *quality* of this centre of
interest in order to determine whether, as has
been said, the subject is worth painting at all.

Composition

My own rule is to spend half the time I am devoting to my sketch in carefully weighing the subject in its every detail and expression.

Many men, I am aware, have endeavored to prove that there are eight or ten different forms of composition. My own experience and investigation are, of course, limited, but so far I have only been able to discover one, namely, the larger mass and the smaller mass: the larger mass dominating the centre of interest, which catches your eye instantly at first sight of a picture, and the smaller or less interesting object which next attracts your eye, and so relieves the vision and spares you the monotony of looking at a single object long and steadily, thus fatiguing the eye and dissipating the interest.

Having determined upon the *quality* of the subject-matter and fixed its centre interest

in pleasing relation to the whole, the next
step is to confine yourself to all that *the eyes
see at one glance* and no more, or, in other
words, that portion of the landscape which you
could cut out with the scissors of your eye and
paste upon your mind. That which you can
see when your head is kept perfectly still, your
eye looking straight before you, only seeing so
high, so low, and so far to the right and left,
without a strain. The great sweep of vision,
a sweep covering a hundred subjects perhaps,
is obtained by turning the eyes up or down or
sideways. But to be true—that is, to see one
picture at a time—the eye should be fixed like
the lens of a camera, the limit of the picture
being the range of the eye and no more. A
departure from this rule not only confuses
your perspective but crowds a number of points
of interest into the square of your canvas,
when there is really only *one* centre point be-
fore you in nature; and this one point you must

treat as does the electrician in a theatre who keeps the lime-light on the star of the play.

Another requirement is rapidity of execution. I am not speaking of figure-drawing. I can well understand why the model grows tired, although the crude lay figure may not, and why the constant workings over and again upon the figure subject, the mosaicing (if I may coin a word) of the different points of the figure during the different hours of the day and the different days of the week deep into the canvas, may be necessary.

I am speaking of outdoor, landscape work, for which only four hours, at most, either in the morning or in the afternoon, can be utilized. In this four hours nature keeps comparatively still long enough for you to caress her with your brush, and if you would truly express what you see, your work must be finished in that time. I can quite understand that to the

ordinary student this is a paralyzing statement,
but let us analyze it together for a moment and
I think that we shall all see that if it were pos-
sible for a human hand to obey us as precisely as
a human eye detects, the results on the can-
vas would be infinitely more valuable, first, be-
cause the sun never stands still and the shadows
of one hour are not the shadows of the next;
and second, because this moving of the sun is af-
fecting not only the mass but the composition of
the picture, one mass of buildings being in light
at ten o'clock and again in shadow at eleven.
It is also affecting its local color, the yellow of
the afternoon sunlight illumining and graying
the silver-blue of the shadows, thus weakening
the force of positive shadows scattered through
the composition. Of course, to be really exact,
there is only one moment in any one of the
hours of the day in which any one aspect of
nature remains the same, but since we are all
finite we must do the best we can, and four

hours, in my experience, is all that a man can be sure of.

We have, of course, the next day to continue in, but then the landscape has changed. That delicate, transparent, gauzy cloud screen that softened the sky light was, under the northwest wind of yesterday, a clear, steely gray-blue, and the sun shining through it made the sunlight almost white and the shadows a neutral blue; to-day the wind is from the south and a great mass of soft summer clouds, tea-rose color, drift over the clear azure, each one of which throws its reflected light on every object over which they float. The half you painted yesterday, therefore, will not match the half you must paint to-day, and so if you will persist in working on your same canvas you go on making an almanac of your picture, so apparent to an expert that he can pick out the Monday, Tuesday, and Wednesday as you daily progressed. If you should be fortunate

enough to work under Italian skies, where
sometimes for days together the light is the
same, the skies being one expanse of soft,
opalescent blue, you might think under such
influence it would be possible for you to per-
form the great almanac trick successfully in
your sketch. But how about yourself? Are
you the same man to-day that you were yester-
day? If so, perhaps you might also find your-
self in exactly the same frame of mind that
existed when your sketch was half finished.
But would you guarantee that you would be
the same man for a week?

I believe we can maintain this position of
the necessity of rapid work in out-of-door
sketches by looking for a moment at the product
of the best men of the last century, some of
whom I have already mentioned. Take Corot,
for instance. Corot, as you know, spent
almost his entire life painting the early light
of the morning. An analysis of his life's work

Composition

shows that he must have folded his umbrella and gone home before eleven o'clock. My own idea is that many hundreds of his canvases, which have since sold at many thousands of francs, were perfectly finished in one sitting. This cannot be otherwise when you remember that one dealer in Paris claims to have sold two thousand Corots. These one-sitting pictures to me express his best work. In the larger canvases in which figures are introduced—notably the one first owned by the late Mr. Charles A. Dana, of New York, called "Apollo," I believe—the treatment of the sky and foreground shows careful repainting, and while the mechanical process of the brush, shown by the over and under painting, the dragging of opaque color over transparent, may produce certain translucencies which the more forcible and direct stroke of the brush—one touch and no more—fails to give, still the whole composition lacks that intimacy with nature which one

always feels in the smaller and more rapidly perfected canvases.

Note, too, the sketches of Frans Hals and see what power comes from the sure touch of a well-directed brush in the hand of a man who used it to express his thoughts as other men use chords of music or paragraphs in literature. A man who made no false moves, who knew that every stroke of his brush must express a perfect sentence and that it could never be recalled. Really the work of such a master is like the gesture of an actor—if it is right a thrill goes through you, if it is wrong it is like that player friend of Hamlet's who sawed the air.

This quality of "the stroke," by the by, if we stop to analyze for a moment, is the stroke that comes straight from the heart, tingling up the spinal column, down the arm, and straight to the finger-tips. Ole Bull had it when his violin echoed a full orchestra; Paderewski has it when he rings clearly and sharply some note that

vibrates through you for hours after; Booth
had it when drawing himself up to his full
height as Cardinal Richelieu he began that fa-
mous speech, "Around her form I draw the holy
circle of our faith"—his upraised finger a bar-
rier that an army could not break down; Ve-
lasquez, in his marvellous picture in the Mu-
seum of the Prado in Madrid of "The Topers"
("Los Borrachos"); Frans Hals, in almost every
canvas that his brush touched; and in later
years our own John Sargent, in many of his
portraits, but especially in his direct out-of-
door studies, shows it; as do scores of others
whose sureness of touch and exact knowledge
have made their names household words where
art is loved and genius held sacred.

And with this ability to record swiftly and
surely there will come a certain enthusiasm,
fanned to white heat when, some morning, trap
in hand, you are searching for something to
paint, your mind entirely filled with a certain

object (you propose to paint boats if you please, and you have walked around them for minutes trying to get the best view and deciding upon the all-important best possible composition)—when, turning suddenly, you face a mass of buildings and a sweep of river that instantly put to flight every idea concerning your first subject, and in a moment a new arrangement is evolved and you are working like mad. It is only under this pressure of *enthusiasm* that the best work is produced.

The coming landscape-painter will be a *four-hour man*, of thorough knowledge, one who has most intimate and close acquaintance with nature, one who can select and then seize the salient features of the landscape, at a glance arranging them upon the square of his canvas, in other words, composing them, the basis being the most expansive and most picturesque grouping of the several details of the sub-

ject, extracting at the same moment, at the same instant, with one sweep of his eye, the whole scheme of local color, and then surely, clearly, lovingly, and reverently making it breathe upon his canvas for other souls to live by.

And how noble the ambition!

In our present civilization some men are moved to philanthropy, some to science, some to be rulers of men. Some men are brimful and running over with harmonies that will live forever. Other men's hearts beat in unison with the symphonies of the spheres, and Homer and Milton and Dante become household words. You seek another expression of the good that is in you. You will be painters and sculptors. Color, form, and mass are to you what the pen, the sword, and the lute are to those others who have gone before, or are now around you. Your mission is as distinct as theirs, and it is

35

as imperative that you should fulfil it. Paint what you see and as you see it. Nothing more nor less. See only the beautiful, and if you cannot reach that content yourself with the picturesque. It is a first cousin but once removed.

MASS

MASS

THE difference between composition and mass is that a composition is a mere outline of pen or pencil, each object taking its proper place in the square of a canvas, while mass is the filling in between these outlines either of varied color or in lights or darks, their gradations but so many guides to the spectator's eye marking not only its perspective, form and atmosphere, but, if skilfully done, telling the story of your subject at a glance.

To do this the student must find the lightest light and darkest dark in the subject before him and, having found it, adhere to it to the end of his work. For as the sun dominates the sky and earth so do its rays dominate parts of the whole, making more luminous than the rest only one object upon which its light falls.

Outdoor Sketching

To make this more explicit it is only neces-
sary to look at an egg upon a white table-cloth.
Here is a natural object devoid of local color
except in reflected lights, and yet you will find
that where the round of the egg reflects the
light the highest light is found, while in the
edge of the shadow, where the egg turns into
the round—between that high light and the re-
flected light from the table-cloth, I mean—is
found its darkest dark. But only one portion
of that shadow, a point as large as the point
of a pin, is the darkest dark. Everything else
is gradation, from the highest light to the lowest
light, the lowest light being almost a shadow;
and from its darkest dark to its lightest dark
the lightest dark again being almost a light.

In landscape art these problems are greatly
simplified. The sun is always the strongest
light, and whatever comes against it, church
tower, rock, palace, or ship under full sail, is
the darkest object. In addition to this there

is always some one point where the outdoor painter can find a lesser supplementary light and near it a lesser supplementary dark. Moreover, throughout the rest of the composition these same lights and darks are echoed and re-echoed in constantly decreasing gradations.

You may apply these same tests everywhere in nature. Even in a gray day, when the sun is not so positive a factor in distributing light, and the shadows are so subtle that it is difficult to discover them, there is always some mass of foliage, the silver sheen from an old shingled roof, the glare of a white wall, which marks for the composition its lightest light, while a corresponding dark can always be found somewhere in the tree-trunks, under the overhanging eaves, or in the broken crevices of the masonry.

So it is with every other expression of nature. Even on a Venetian lagoon, where the sky and

water are apparently one (not really one to the quick eye of an expert, the water always being one tone lower than the sky—that is, more gray than the overbending sky)—even in this lagoon you will find some one portion of the surface lighter than any other portion; and in expressing it your eye first and your brush next must catch in the opalescent sweep of delicious color under your eye its exact quantity of black and white. By black and white I mean, of course, that excess or absence of pure color which when translated into pure black and white would express the meaning of the subject-matter, as one of Raphael Morghen's engravings on steel gives you the feeling and color in his masterly rendering of Da Vinci's "Last Supper."

In my judgment one of the great landscapes of modern times is the picture by the distinguished Dutch painter, Mauve, known as "Changing Pasture," which is now owned by

Mass

Mr. Charles P. Taft, of Cincinnati. Here the factor of mass is carried to its utmost limit. Sky one mass; flock of sheep another mass; and the foreground, sweeping under the sheep and beyond until it is lost in the haze of the distance, another mass, or, if one chooses to put it that way, another broad gradation of a section of the picture: the highest light being some infinitesimal speck in the diaphanous silver sky, the strongest dark being found somewhere in the foreground or in the flock of sheep.

By a strict adherence to this law of one supreme light and one supreme dark does Mauve's work, as it were, get back from and out of his canvas, as from the record of a phonograph into which some soul has breathed its own precise purpose and intent.

So, too, does nature often call out to you fixing your attention, often shrouding in shadow the unimportant in the landscape, while high up above the gloom it holds up to your gaze a

white candle of a minaret or the bared breast of an Alpine peak reflecting the loving look of a tired sunbeam bidding it good-night.

To accent the more strongly the value of this dominant light even though it be treated in very low gradation, I recall that a year ago the art world was startled by the sum received for a medium-sized picture of some coryphées painted by Degas, now an old man over eighty years old—a subject which he always loved and, indeed, which he has painted many times. Some thirty years ago, when he was comparatively a young man, I saw, at the Bartholdi exhibition in New York, a picture by this master of these same coryphées, two figures standing together in the flies resting their weary, pink, fishworm legs as they balanced themselves with their hands against the wabbling scenery. It was a wholly gray picture, and almost in a monotone, and yet the flashes of their diamond

44

earrings, no larger than the point of a pin, were distinctly visible, holding their place in, if not dominating, the whole color scheme.

Again, in that marvellous portrait of Wertheimer, the bric-à-brac dealer, if you remember, the eye first catches the strong vermilion touch on the lower lip, and then, knowing that a master like Sargent would not leave it isolated, one finds, to one's delight and joy, a little swipe of red on the tongue of the barely discernible black poodle squatting at his feet. Had the red of the dog's tongue predominated, we should never have been thrilled and fascinated by one of the great portraits of this or any other time.

This 'is also true in other great portraits—in, for instance, the pictures of Rembrandt, Vandyck, and Frans Hals, especially where a face is relieved by the addition of a hand and the white of a ruff. Somewhere in that warm expanse of the face there can be found a pin-

head of color, brighter and more dominating than any other brush touch on the canvas. It may be the high egg-light in the forehead, or the click on the tip of the nose, or a fold of the white ruff; but slight as it is and un-noticeable at first, because of it not only does the head look round as the egg looks round when relieved by the same treatment, but the attention is fixed. Unless this had been pre-served, the eye would have, perhaps, rested first on the hand, something foreign to the painter's intention.

Recalling again the law of the high light and strong dark, and referring again to the value of the skilful manipulation of light and shade forming the mass thereby expressing the more clearly the meaning of a picture, I repeat that, while the eye is always caught by the strongest dark against the strongest light, it is next caught by the lesser supplementary light and lesser supplementary dark; and then, if

the painter is skilful enough in the manage-
ment of the remaining lesser lights and darks,
the eye will run through the gradations to the
end, rebounding once more to the greater light
and dark, exactly in the order intended by the
painter; thus unfolding to the spectator little
by little, quite as a plot of a novel is made clear,
the story which the painter had in his own mind
to tell. This is effected purely and entirely
by the correct accentuations of the explanatory
lights and darks. One mistake in the manage-
ment—that is, the accentuating of the third
light, if you please, instead of the second—will
not only confuse the eye of the spectator, but
may perhaps give him an entirely different
impression from what was intended by the
painter, just as the shifting of a chapter in a
novel would confuse a reader; and this, if you
please, without depending in any way upon either
the drawing or the color of the accessories.

I can best illustrate this by recalling to your

mind that marvellous picture of the so-called literary school of England, a picture by Luke Fildes known as "The Doctor" and now hanging in the Tate Gallery in London, in which the whole sad story is told in logical sequence by the artist's consummate handling of the darks and lights in regular progression.

You will pardon me, I hope, if I leave the more technical details of my subject for a moment that I may discuss with you one of the peculiarities of the so-called art-loving public of to-day, notably that section which insists that no picture should tell a story of any kind.

To my own mind this picture of Luke Fildes reaches high-water mark in the school of his time, and yet in watching as I have done the crowds who surge through the Tate Galleries and the National Gallery, it is an almost every-day occurrence to overhear such contemptuous remarks as "Oh, yes, one of those literary fel-

lows," drop from the lips of some highbrow who only tolerates Constable because of the influence his example and work had on Corot and other men of the Barbizon school.

Another section lose their senses over pure brush work.

A story of Whistler—one he told me himself —will illustrate what I mean. Jules Stewart's father, a great lover of good pictures and one of Fortuny's earliest patrons, had invited Whistler to his house in Paris to see his collection, and in the course of the visit drew from a hiding-place a small panel of Meissonier's, of a quality so high that any dealer in Paris would have given him $30,000 for it.

Whistler would not even glance at it.

Upon Stewart insisting, he adjusted his monocle and said: "Oh, yes, very good—*snuff-box style.*"

This affectation was to have been expected of Whistler because of his aggressive mental

attitude toward the work of any man who han-
dled his brush differently from his own personal
methods, but saner minds may think along
broader lines.

If they do not, they have short memories.
Even in my own experience I have watched
the rise and fall of men whose technic called
from the housetops—a call which was heard
by the passing throng below, many of whom
stopped to listen and applaud; for in pictures
as in bonnets the taste of the public changes
almost daily. One has only to review several
of the schools, both in English and in Conti-
nental art, noting their dawn of novelty, their
sunrise of appreciation, their high noon of tri-
umph, their afternoon of neglect, and their
night of oblivion, to be convinced that the wheel
of artistic appreciation is round like other
wheels—the world, for one—and that its revo-
lutions bring the night as surely as they bring
the dawn.

Mass

Not a hundred years have passed since the broad, sensuous work of Turner, big in conception and big in treatment, was followed by the more exact painters of the English school, many of whom are still at work, notably Leader and Alfred Parsons, both Royal Academicians, and of whom some contemporaneous critic insisted that they had counted the leaves on their elm-trees fringing the polished water of the Thames. They, of course, had only been eclipsed by the broader brushes of more recent time, men like Frank Brangwyn and Colin Hunter, who have yielded to the pressure of the change in taste, or of whom it would be more just to say, have *set* present taste, so that to-day not only the afternoon of night, but the twilight of forgetfulness, is slowly and surely casting long shadows over the more realistic men of the eighties and nineties.

What will follow this evolution of technic no man can predict. The lessons of the past,

however, are valuable, and to-day one touch of Turner's brush is more sought for than acres of canvases so greatly prized twenty years after his death.

And this is not alone confined to the old realistic English school. In my own time I have seen Verbeckoeven eclipsed by Van Marcke, Bouguereau, Cabanel, and Gérôme by Manet, and Sir Frederick Leighton by John Sargent—a young David slaying the Goliath of English technic with but a wave of his magic brush—and, last and by no means least, the great French painter Meissonier by the equally great Spanish master Sorolla.

I am tempted to continue, for the success of these men in the fulness of the sunlight of their triumph, realists as well as impressionists, was wholly due to their understanding of and adherence to the rules of selection, composition, and mass which form the basis of these papers, and which despite their differences in brush work they all adhered to.

Mass

In the late half of the preceding century Meis-
sonier received $66,000 for his "Friedland,"
a picture which cost him the best part of two
years to paint, and the expenditure of many
thousands of francs, notably the expense at-
tendant upon the trampling down of a field of
growing wheat by a drove of horses that he
might study the action and the effect the bet-
ter. Forty years later Sorolla received $20,000
for two figures in blazing sunlight which took
him but two days to paint, the rest of his collec-
tion bringing $250,000, the whole exhibit of one
hundred and odd pictures having been visited
by 150,000 persons in thirty-two days. And
he is still in the full tide of success, pre-emi-
nently the greatest master of the out-of-doors of
modern times, while to-day the work of Meis-
sonier has fallen into such disrepute that no
owner dares offer one of his canvases at public
auction except under the keenest necessity.
The first master expresses the refinement of ex-
treme realism, or rather detailism; the other is a

pronounced impressionist of the sanest of the open-air school of to-day. How long this pendulum will continue to swing no one can tell. Both men are great painters in the widest, deepest, and most pronounced sense; both men have glorified, ennobled, and enriched their time; and both men have reflected credit and honor upon their nation and their school.

Meissonier could not only draw the figure, give it life and action, keep it harmonious in color, perfect in its gradations of black and white, but he had that marvellous gift of color analysis which reproduces for you in a picture the size of the top of a cigar-box every tone in the local and reflected light to be found, say, in the folds of a cavalier's cloak, the pleats no wider than the point of a stub pen.

All this, of course, Sorolla ignores and, I am afraid, knowing the man personally as I do, despises. What concerns the great Spaniard is the whole composition alive in the blaze of the sunlight, the glare of the hot sand and the

54

shimmer of the blue, overarching sky, beating up and down and over the figures, and all depicted with a slash of a brush almost as wide as your hand. The first picture, the size of a tobacco-box, you can hold between thumb and finger and enjoy, amazed at the master's knowledge and skill. The other grips you from afar off as you enter the gallery and stand startled and astounded before its truth and dignity. In the first Meissonier tells you the whole story to the very end. ↑ In the second Sorolla presents but a series of shorthand notes which you yourself can fill in to suit your taste and experience both of life and nature.

Whether you prefer one or the other, or neither, is a matter for you to decide. You pay your money or you don't, and you can take your choice. The future only can tell the story of the revolution of the wheel. In the next decade a single Meissonier may be worth its weight in sheet gold and layers of Sorollas may be stored in attics awaiting some fortunate auction.

Outdoor Sketching

What will ensue, the art world over, before the wheel travels its full periphery, no man knows. It will not be the hysteria of paint, I feel assured, with its dabbers, spotters, and smearers; nor will it be the litters of the cub-ists, that new breed of artistic pups, sponsors for "The girl coming down-stairs," or "The stairs coming down the girl," or "The coming girl and the down-stairs," it makes no difference which, all are equally incoherent and unintelligible; but it will be something which, at least, will boast the element of beauty which is the one and only excuse for art's existence. I may not live to see Meissonier's second dawn and I never want to see Sorolla's eclipse, but you may. You have only to remember Turner's second high noon to be assured of it.

And just here it might be well to consider this question of technic, especially its value in obtaining the results desired. While it has

nothing to do with either selection, compo-
sition, or mass, it has, I claim, much to do with
the way a painter expresses himself—his tone
of voice, his handwriting, his gestures in talk-
ing, so to speak—and therefore becomes an in-
tegral part of my discourse. It may also be of
service in the striking of a note of compromise,
some middle ground upon which the extremes
may one day meet.

To make my point the clearer, let me recall
an exhibition in New York, held some years ago,
when the bonnets were five deep trying to get
a glimpse of a picture of half a dozen red prel-
ates who were listening to a missionary's story.
Many of these devotees went into raptures over
the brass nails in the sofa, and were only disap-
pointed when they could not read the monogram
on the bishop's ring. Later on, a highly culti-
vated and intelligent American citizen was so
entranced that he bought the missionary, story
and all, for the price of a brown-stone front, and

57

carried him away that he might enjoy him forever.

One month later, almost exactly in the same spot hung another picture, the subject of which I forget, or it may be that I did not understand it or that it had no subject at all. If I remember, it was not like anything in the heavens above, or the earth beneath, or the waters under the earth. In this respect one could have fallen down and worshipped it and escaped the charge of idolatry. With the exception of a few stray art critics, delighted at an opportunity for a new sensation, it was not surrounded by an idolatrous gathering at all. On the contrary, the audience before it reminded me more of Artemas Ward and his panorama.

"When I first exhibited this picture in New York," he said, "the artists came with lanterns before daybreak to look at it, and then they called for the artist, and when he appeared— they threw things at him."

Mass

For one picture a gentleman gave a brown-stone front; for the other he would not have given a single brick, unless he had been sure of planting it in the middle of the canvas the first shot. The first was Vibert's realistic picture so well known to you. The other was an example of the modern French school or what was then known as advanced impressionists.

I shall not go into an analysis of the technic of the two painters. I refer to them and their brush work here because of the undue value set upon the way a thing is done rather than its value after it is done.

Speaking for myself, I must admit that the value of technic has never impressed me as have the other and greater qualities in a picture—namely, its expression of truth and the message it carries of beauty and often tenderness. I have always held that it is of no moment to the world at large by what means and methods an artist expresses himself; that

the world is only concerned as to whether he has expressed himself at all; and if so, to what end and extent.

If the artist says to us, "I scumbled in the background solid, using bitumen as an undertone, then I dragged over my high lights and painted my cool color right into it," it is as meaningless to most of us as if another breadwinner had said, "I use a Singer with a straight shuttle and No. 60 cotton." What we want to know is whether she made the shirt.

Art terms are, however, synonymous with other terms and in this connection may be of assistance. To make my purpose clear we will suppose that "technic" in art is handwriting. "Composition," the arrangement of sentences. "Details," the choice of words. "Drawing," good grammar. "Mass, or light and shade," contrasting expressions giving value each to the other. I hold, however, that there is something more. The author may

write a good hand, spell correctly, and have
a proper respect for Lindley Murray, but what
does he say? What idea does he convey? Has
he told us anything of human life, of human
love, of human suffering or joy, or uncovered
for us any fresh hiding-place of nature and
taught us to love it? Or is it only words?

It really matters very little to any of us what
the handwriting of an author may be, and so
it should matter very little how an artist
touches the canvas.

It is true that a picture containing and ex-
pressing an idea the most elevated can be
painted either in mass or detail, at the pleasure
of the painter. He may write in the Munich
style, or after the manner of the Düsseldorf
ready writers, or the modern French pothook
and hanger, or the antiquated Dutch. He can
use the English of Chaucer, or Shakespeare, or
Josh Billings, at his own good pleasure. If he
conveys an intelligible idea he has accom-

plished a result the value of which is just in proportion to the quality of that idea.

To continue this parallel, it may be said that extreme realism is the use of too many words in a sentence and too many sentences in a paragraph; extreme impressionism, the use of too few. Neither, however, is fundamental, and art can be good, bad, or indifferent containing each or combining both.

Realism, or, to express it more clearly, detailism, is the realizing of the whole subject-matter or motive of a picture in exact detail. Impressionism is the generalizing of the subject-matter as a whole and the expression of only its salient features.

The extreme realist or detailist of the Ruskin type has for years been insisting that a spade was a spade and should be painted to look like a spade; that a spade was not a spade until every nail in the handle and every crack in the blade became apparent.

Mass

The more advanced would have insisted on not only the fibre in the wood, but the brand on the other side of the blade, had it been physically possible to show it.

In absolute contrast to this, there lived a man at Barbizon who maintained that a spade was not a spade at all, but merely a mass of shadow against a low twilight sky, in the hands of a figure who with uncovered head listens reverently; that the spade is merely a symbol of labor; that he used it as he would use a word necessary to express a sentence, which would be unintelligible without it, and that it was perfectly immaterial to him, and should be to the world, whether it was a spade or a shovel so long as the soft twilight, and the reverent figures wearied with the day's work, and the flat waste of field stretching away to the little village spire on the dim horizon line told the story of human suffering and patience and toil, as with folded hands they listened to the soft cadence of the angelus.

Outdoor Sketching

Which of these two methods of expression is correct—Ruskin or Millet? Are there any laws which govern, or is it a matter of taste, fancy, or feeling? Is it a matter of individuality? If so, which individual by his methods tells us the most truths? Let us endeavor to analyze.

I whirl through a mountain gorge and catch a glance through a car-window—an impression. In the darkness of the tunnel it remains with me. I see the great mass of white cumuli and against them the dark cedars, the straggling foot-path and steep cliffs. I am impressed with the sweep of the cloud form pressing over and around them. With my eyes closed I paint this on my brain, and if I am great enough and wide enough and deep enough I can subdue my personality and forget my surroundings, and when opportunity offers I can express upon my canvas the few salient facts which impressed me and should impress my fellow men. If it is

the silvery light of the morning, I am Corot; if the day is gone and across the cool lagoon I see the ripple amid the tall grass catching the fading color of the warm sky, I am Daubigny; if a gray mist hangs over the hillside and the patches of snow half melted express the warmth and mellowness of the coming spring, I am our own Inness.

Perhaps, however, I am not content. I am overburdened with curiosity. I say to myself: "What sort of trees, pine or cedar?" I think, pine, but I am uneasy lest they should be hemlock. Were the rocks all perpendicular, or did not detached bowlders line the path? About the clouds, were they not some small cirri beneath the zenith? My memory is so bad—and so I stop the train and go back. Just as I expected. The trees were spruce and the rocks were grass-grown and full of fissures, and so I begin to paint and continue. I get the bark on the trees, and the foliage until each par-

ticular leaf stands on end, and the strata of the cliffs, and the very sand on the path. I crowd into my canvas geology, botany, and the laws governing cloud forms.

Being an ordinary mortal, my curiosity, my telescopic eyes, my magnifying-glass of vision, my love of truth, my positive conviction that it is a spruce and should not be painted as a pine, except through rank perjury, all these forces together have undermined my impression or, like thorns, have grown up and choked it. Being honest, I am ready to confess that before returning to the spot I was in doubt about the pine. But I am still ready to affirm that what I have labored over is the exact counterfeit and presentment of nature, and equally willing to denounce the public for not seeing it as I do. I forget that I have been a boor and a vulgarian—that I have been invited to a feast and that I have pried into mysteries which my goddess would veil from

my sight; that I have had the impertinence to bring my own personal advice into the discussion; that I have insisted that fissures, and leaves, and sand, and infinite detail were necessary to this expression of nature's sublimity.

Is it at all strange that the impression which so charmed me as I saw it from my car-window has faded? Nature unrolled for me suddenly a poem. For symbols she used a great mass of dark, sturdy trees against a majestic cloud, a rugged cliff, and a straggling path. I have ignored them all and insisted that "truth was mighty and must prevail." I am a realist and "paint things as they are." Not so. I am an iconoclast and have broken my god and cannot put together the pieces. I have sacrificed a divine impression to a human realism.

Suppose, however, that the painter who had this glimpse of nature before entering the tunnel was no ordinary man, but a man of steadfast mind, of firm convictions, of a sure touch, with

an absolute belief in nature, and so reverential
that he dare not offer even a suggestion of his
own. He has seen it; he has felt it; it has gone
down deep into his memory and heart. The
cloud, the cliff, the mass, the path—that is all.
And it is enough. The annoyances of the day,
the seductions of fresh impressions of newer
subjects, the weakness of the flesh do not deter
him. With a single aim, to the exclusion of
all else, and with a direct simplicity, he records
what he saw, and lo! we have a poem. Such a
man was Courbet, Corot, Dupré.

But one would say: That may answer for
landscape: what about the figure-painter? Let
us counsel together.

A man only rises to his own level. In art,
as in music and literature, he only expresses
himself. Each selects his own method. The
school of Meissonier is not content with a few
grand truths simply expressed. They want a
multitude of facts; they must tell the story in

their own way. They are the Dickens and Wal-
ter Scott of art. It is iteration and reiteration.
My cardinal must not only have red stockings,
says Vibert, but they must be silk; every detail
must be elaborated. Very well, what of it?
you say. What do you criticise, the drawing?
No. The color? No. The composition? No.
Does the painter express himself? Perfectly.
What then? Just this. He expresses himself
too perfectly. At first I am delighted. The
story is so well told—the well-fed prelates; the
half-sneer; the cynical smile; the earnest mis-
sionary telling his experience. But the next
day?—well, he is still telling it. By the end
of the week the enjoyment is confined to allow-
ing him to tell it to a fresh eye, and that eye
another's, and watching his pleasure. At the
end of the year it becomes a part of the decora-
tion of the wall. You perhaps feel that the
frame needs retouching, and that is all the im-
pression it makes upon you, except as would

an old timepiece with the mainspring gone. The works are exquisite and the enamelling charming, but it has been four o'clock for forty years.

In the library, however, hangs an etching which you often look at; in fact, you never pass it without noticing it. Two figures, a wheelbarrow, a spade, a stretch of country, a spire pencilled against a low-tone sky; and yet, somehow, you hear the tolling of the bell and the whispered prayer. Ah! but you say this has nothing to do with the treatment; it is the subject. One moment. The missionary's story is as full of pathos and of human suffering and courage as the "Angelus," and at first as profoundly stirs our sympathy; but, in one, Vibert has monopolized the conversation; he has exhausted the subject; he has told you everything he knows. Nothing has been omitted; nails, monograms, and all; there is nothing left for you to supply—he is not so complimentary. But Millet has taken you into

his confidence. He says: "Come, see what I once saw. Do you ever remember any such couple working in the field?" And you immediately, and unconsciously to yourself, remember just such a bent back and reverent, uncovered head. Where, you cannot tell, for the picture comes to you out of the dim lumber-room in your brain where you store your old memories and faint impressions of bygone days and sad faces.

But if he added, "See, my peasant wears a woollen jacket trimmed with worsted braid," your impression would immediately fade. You might remember the jacket, but the braid, never. But for this it would have been delightful for you, although unconsciously, to add your own sweet memory to the picture.

Another impression choked to death with unnecessary realism.

But be you realist or impressionist, remember that a true work of art is that which has pleased

Outdoor Sketching

the greatest number of people for the longest period of time; that the love of beauty indicates our highest intellectual plane, and that if you will express to your fellow sinners burdened with life's cares something of the enthusiasm of your own life, and will assist them to see their mother earth through your own eyes in constantly increasing beauty—you having by your art, in your possession, the key to the cipher, and interpreting and translating for them—you will confer upon them one of the greatest blessings which fall to their lot on this mundane sphere.

WATER-COLORS

WATER-COLORS

COLOR, if you stop to think, is really the decorative touch which God gives to the universe. It would have been just as easy to make everything gray—every rose but the shadow of itself—every tree and rock and cloud a monotone of gradation. Instead of that, everything we look at, from a violet to an overbending sky, is enriched and glorified by millions of color tones as infinite in their gradation as the waves of sound and light. Even in the grayest days, when the clouds are bursting into tears and the whole landscape is desolate as the barrenest and bleakest of mountain sides, these infinite gradations of color permeate and redeem its barrenness, and to the true painter fill it with joy and beauty.

Outdoor Sketching

There are many of us, however, who are not true painters and to whom the most exquisite of color schemes are but dull results. Many of us walk around our galleries passing the best pictures in silence; others ridicule what they cannot understand. Even our own beloved Mark Twain, whose heart was always open to the best and warmest of human impressions, and who expressed them in every line of his pen, when led up to one of Turner's masterpieces, "The Slave Ship," a glory of red, yellow, and blue running riot over a sunset sky, the whole reflected in a troubled sea, remarked to his companion: "Very wonderful! Seen it before. Always reminds me of a tortoise-shell cat having a fit in a plate of tomato soup."

The education of such barbarians belongs to our generation and should be taken up by those of us who know or think we do. For true color is as great an educator as true music.

Water-Colors

This knowledge of color harmony, this match-
ing and contrasting of different colors, but very
few men and women possess. When they do, it
is generally inherited and thus a natural gift.
The rest of the world wear blue and purple,
or orange and green, entirely ignorant of the
harmonies of nature even as bearing on their
domestic surroundings. For myself, I have
always held that the most perfect harmonies
required in either wall decoration, furniture,
dress goods, or any other fabrics that color en-
ters into, have their exact counterpart in some
color tones of nature—that the russet-browns
and yellows of autumn; the contrasting opal-
escent hues of a morning sky, rose-pink, pale
blue, or delicate tea-rose yellow; the gloom
of a forest with its yellow-grays and blue-grays,
the gray-green moss of the lichens, the brown
of the tree-trunks, the black and gray hues of
the rocks, all these, if carefully studied and
analyzed and reproduced, would make beauti-

ful anything in the world from a bonnet to a château. To illustrate:

Several years ago an intimate friend of mine, a distinguished architect of New York, the late Mr. Bruce Price, in designing a number of cottages at Tuxedo sought in vain for some color mixture. current in the paint-shops with which to cover the outside of his buildings. All schemes of browns, olive-greens, colonial yellow with white trimmings and the reverse, Pompeiian reds, slate-grays, and dull yellows resulted in making "spots" of the houses, so that the effect he wished to produce, that of the houses being merged into the forest, was lost. Mr. Price was not only an architect, but he was an artist as well. He had little skill with his brush, but he had that innate good taste, with a keen eye to discern the subtle gradations in color, that only needed change of occupation to make him a painter. One day, looking at a new bare wooden cottage—unpainted

as yet—in contrast to a mass of foliage in the
early autumn before the leaves had begun to
turn, in which the yellow-grays one often sees
predominated, he suddenly thought to him-
self: "The tree-trunks and underbrush do not
stand out; they are all of one piece, each keep-
ing its place, while my house"—as he rather
inelegantly but forcibly expressed it—"sticks
up like a sore thumb." Later, this very clever
man made an analysis of the local color in these
several grays, and his subsequent matching
and combining of these different tints resulted
in the exact tones of the forest before him,
and when this was completed and the house
painted you felt should you enter the front
door that the leaves must be over your
head.

Bringing the discussion down to more prac-
tical details, really to the palettes which we
hold in our hands, the question then naturally
arises as to how best to express true local color,

with its varying blues, yellows, and reds, and especially its varying grays.

In my own experience I find grays to be the prevailing tones everywhere in nature.

I find also that the great masters of modern art, particularly the school of 1830, known as the Barbizon school, and represented by such men as Rousseau, Corot, Daubigny, Diaz, and Millet, and later by men who in some degree represent that school, but to my mind have done work equally good—even Monténard and Cazin—that all these masters have loved, sought for, and expressed in their work this all-prevailing quality, the gray.

A few very simple rules for testing the power, presence, and quality of the prevailing gray in nature are so easily learned and so convincing in their application that once applied they are never forgotten.

Take, for instance, a morning in late spring or early summer, when all nature is dressed

from tree-top to grass-blade in a suit of vivid green. To a tyro with so dangerous a weapon as a color-box, there is nothing that will really bring down this game but some explosive composed of indigo and Indian yellow, or Prussian blue and light cadmium—perhaps the strongest mixture of vivid raw green.

Now, pluck a single leaf from a near-by branch, hold it close to one eye, and with this as a guide note the difference in color tones between it and the leaves on the tree from which you plucked the leaf and which you had believed to be a vivid green. To your surprise, the leaf itself, even with the sun shining through it, is many tones lower and grayer than the color of the near-by branch as depicted on your paper, while the near-by branch, in comparison, pales into a sable gray-green, which you could perhaps get with yellow ochre, blue-black, and a touch of chrome-yellow.

Outdoor Sketching

It does not seem to me that I can better illustrate this quality of the gray than by rapidly going over some of the works of George Inness lately on exhibition in New York—certainly to me the most marvellous examples of the power of a human mind to harmonize the subtle colorings of nature. I select Inness not only because he is to me one of the great landscape-painters of his day, but because he chooses a very wide range of subjects, from early morning to twilight, expressing these truthfully, absolutely, perfectly, so far as local color is concerned—that is, of course, as I see through either my own spectacles or Inness's; but, then, remember, our eyes may need repair. When these canvases are analyzed we find in the range of color nothing stronger than yellow ochre in yellows, than light red in reds, and, with hardly an exception, blue-black for blues. Indeed, his usual palette, as does Mauve's and Cazin's, seems to me to be only yellow ochre and

blue-black, and with these two colors he expresses the whole range of the color scheme in nature, with the varying lights of day and night, except in depicting sunsets.

After the salient features of a landscape have been analyzed and recorded in color, the more subtle qualities are to be detected and expressed. The most important of these is the time of day. To an outdoor painter—an expert examining the work of another expert—the hour-hand is written over every square inch of the canvas. He knows from the angle of the shadows just how high the sun was in the heavens, and he knows, too, from the local color of the shadows whether it is a silvery light of the morning, the glare of noontime, or the deepening golden glow of the afternoon. In fact, if you will think for a moment, the shadow of an overhanging balcony upon a white wall is a perfect sun-dial for

him, and this test can be indefinitely applied to every part of the picture.

The next is the temperature: how hot or how cold it was—what month in the year? It is unnecessary for Inness to cover his ground with snow to make his picture express a certain degree of cold, neither is it necessary for Monténard to fill his Provençal roads with clouds of dust to show how hot they are. This is done by the opalescent tones of the sky, by the values expressed in reflected lights and in the illuminated shadows, so that you feel in looking across one of Inness's fields of brown grass just how late is the autumn and just how cool it has been, and in looking down one of Monténard's roads you realize how useless would be an overcoat.

In this connection let me say that all nature is interesting and all nature is beautiful, but all nature, as I have said, is not paintable. The interior of a railroad station, for instance, is

Under the Willows, Cookham-on-Thames

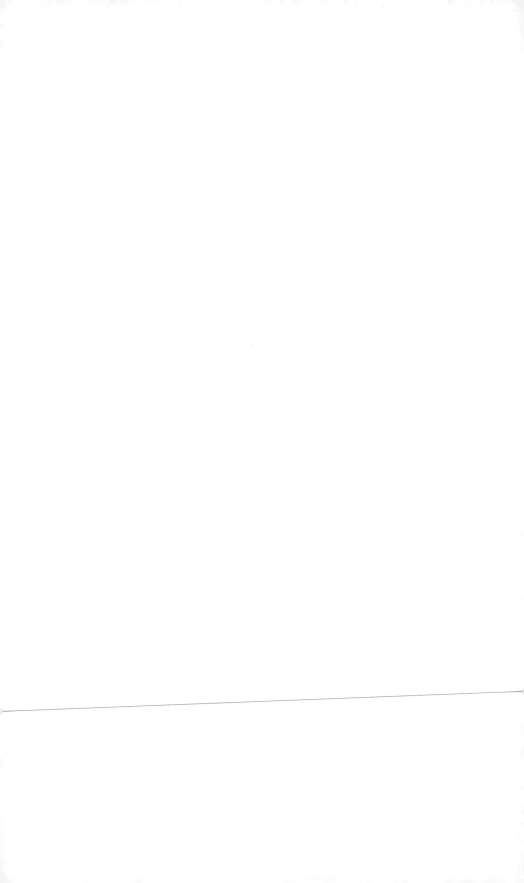

interesting, as giving you certain mechanical results, construction, but it is not picturesque —that is, paintable—unless one could treat it as Pennell does, contrasting the black cars and locomotive with a puff of white steam, giving the vistas with the perspective of track, and a centre mass of people adding an idea of movement and color.

Above all, the outdoor painter should get the character and feeling of the place he portrays on his canvas. If in Spain, his picture must look like Spain. The air must be transparent, the architecture clean-cut against the azure. If it be Holland, the atmosphere must be moist, the air like a veil, and with all this there must be nothing in the work that will be mistaken for the smoke-laden air of England. Only thus, by this fidelity to the very nature and spirit of a place, can the picture be made to express the essence of its life, which is really the heart of the whole mystery.

Outdoor Sketching

Coming at last to our text, Water-Colors—the art of depicting nature on a sheet of white paper by paints diluted with water—it will be well to remind you that the art goes back to almost prehistoric times. A few weeks ago, in the library of Mr. Jesse Carter, director of the American Academy in Rome, I saw one of the earliest water-colors in existence. It was painted upon a sheet of slate, and, although some thousands of years old, still retained its color and remarkable brilliancy. The subject was a group of figures, the centre object being a girl of wonderful grace.

The present art of water-color painting, with a sheet of white paper as background instead of the permanent stone, is, however, but little more than one hundred and fifty years old, and owes its existence largely to the men of the English school.

Mr. C. E. Hughes, in his delightful book on "Early English Water Color," confined this

English school to the men born between the years 1720 and 1820.

In this group he places the great Gainsborough, who from 1760 to 1774 worked "in charcoal and water-color on tinted paper," which he said he "loved to dash off of an evening, and which dazzled the fine ladies and gentlemen who frequented the select watering-place of Bath," where he was then living.

Then came Robert Cozens, the brothers Sanby, Thomas Hearne, Thomas Malton, Samuel Scott, and a few others, all known as the eighteenth-century painters.

These were succeeded by Thomas Girtin, who was born in 1775 and died at twenty-seven years of age; and the great J. M. W. Turner, who first saw the light in the same year, and on the day on which all great Englishmen should be born—namely, April 23—a day dedicated to St. George and the birthday of William Shakespeare.

Outdoor Sketching

Girtin and Turner worked together. Girtin, measured by the standard of to-day, was an extreme impressionist, leaving behind him sketches dashed in with an appearance of freedom which Peter DeWint and David Cox might have envied when in after years they were at the height of their power. Turner, on the contrary, devoted his time to acquiring that triumphant grasp of detail which caused him to be known in his earlier life as an extreme realist.

The change in Turner's work—the broader brush—came in his later years when oil became his medium of expression, in which, no doubt, his ability to note and yet sacrifice all unnecessary detail was a potent factor.

A list of Englishmen greatly prized in their day now follows. Such men as John Varly, Gilpin, Glover, William Havell (all of whom during some part of their careers were members of the first Water Color Society formed in

England, in 1804, which body still survives in the old Water Color Society whose rooms are still open on Pall Mall East) rose into prominence, their works finding places both in private and public collections.

This society was in turn succeeded by the New Society of Painters in Miniature and Water Colors, which came into being in 1807 and went out of existence in 1812—a victim, says Hughes, of the condition of public apathy which brought about in the same year a reconstruction of the older organization under the joint title of the Oil and Water Color Society, and which eked out a precarious existence until the birth of the association now known as the Royal Institute for Painters in Water Colors.

Other names now confront us, among them two men, David Cox and Peter DeWint, who in their day were considered masters of the medium. These last struck a new note in

water-color, or rather a new technic in its
handling. What Ruskin, the realist, in his
"Modern Painters" describes as "blottesque"
was at that time looked upon by both teachers
and students as the one and only means by
which white paper could be properly stained.
This method, to quote from a loyal believer
in the English transparent school, and whose
enthusiasm is delightful, was the laying on of
the color in washes which filled certain defi-
nite spaces indicated by a pen-and-ink outline.

These washes would indicate, say, a distant
tree with a preliminary tint and a subsequent
elaboration; he would do it all in one process,
giving his blot an irregular edge and allowing
the color to accumulate where the shadows re-
quired it. His elaborative touches elsewhere
were of the same nature. They were brush
blots as distinct from washes. To this, I think,
we may attribute on analysis the freedom of
handling which—though each man has his dis-

tinctive method—is characteristic of both Cox and DeWint. If we add to these two methods of using the brush a third—its manipulation as though it were a pen—we shall have all the fluid processes on one or the other of which the beauty of all modern water-color drawings depends. A fourth process is rubbing the color into the grain of the paper. A fifth—a supplementary one—is scratching out. Last is the ignominy of the stipple—the wetting of the brush in the mouth, a technic entirely dependent upon the quantity of saliva the student can spare for his work. Almost every early wash water-color in existence can be classified according to the employment in its making of some or all of these means.

In later years, especially in the last half of the eighteenth century, we have Copley Fielding; Prout, with his picturesque sepia drawings, the detail of his architecture in brown ink; Harding; Bonnington, really a great man;

Outdoor Sketching

Clarkson Stanfield; Rowbotham; David Roberts; James Holland; Cattermole, who declined a knighthood and whose intimates were Dickens, Disraeli, and Thackeray; and so on down to the men of to-day, who are so well and ably represented in the annual exhibitions of the Royal Academy and the present English Water Color Societies.

As for our own progress in the art, the subject, of course, is too well known for long discussion. Our oldest society, the American Water Color Society, held its first public exhibition in the National Academy of Design in New York in 1867, a date always remembered by me with infinite pride and pleasure, for upon the walls of the smallest room close up under the roof was hung my first exhibited watercolor—the only one of my three the hanging committee were good enough to accept. Two years later—I am happy to say—in 1869, I was

elected a member, and I am further happy to say that I am still in good standing and in high-hanging, and have so continued from that day down to the present time—a trifle of some forty-six years.

As to my compatriots, I can truthfully say that its membership covers some of the great water-colorists of our own or any other time, both here and abroad—men entirely free to do as they pleased, working in anything and all things so long as, to use their own expression, they "get there," handling body color, in a veil of silver-gray as an overwash or squeezed in chunks from a tube; undertones of charcoal gray, overtones of pastel—anything for *quality*.

Their names are legion: the late E. A. Abbey, Walter Palmer, Chase, the late Robert Blum, F. S. Church, Cooper, Curran, Eaton, Farrer, the two Smillies, Childe Hassam, Keller, Murphy, Nicoll, Potthast, the late Henry Smith, etc., etc.

Outdoor Sketching

These are but a haphazard choice of the men whose work shows the widest ranges in selection, composition, mass, and technic, and who, in the world of water-color painting, are masters of the medium.

As to our progenitors, the English water-color school—and I make the statement with every respect for their high accomplishments—while I believe we are indebted to them for the very existence of the art itself, I must say that our own men and art-lovers the world over would have been vastly benefited had these English-men allowed themselves a little more freedom in their methods and not followed so blindly the traditions of their past.

That we broke away so early is as much a question of race as of training. The last idea that enters the heads of our own men is that they want either to paint or to draw like some-body else. They all want to paint like them-selves, or they do not want to paint at all.

Water-Colors

They are so many art sponges. They go abroad,
wander about the Grosvenor and the exhibi-
tions, run over to Paris and haunt the Salon
and shops, and so on to Munich and Berlin,
picking up a technical touch here or a new idea
of grouping or mass or color scheme there, and
then, having thoroughly absorbed it all, return
home and use whatever suits them; but a
slavish imitation of any one English, French,
or German master—never; neither do they
follow any other brush at home. They do not
believe in each other sufficiently to pay the
highest form of flattery—imitation.

Nor do many of them find their subjects
abroad—a habit practised these many years by
your humble speaker, whose only excuse is that
he *must* paint, no matter where he is, and that
his life in the summer-time is dominated by his
two children, both exiles, and more exactingly
still in late years by two little grandboys who
have not as yet crossed the ocean. No, these

young American painters, with hardly an exception, find their subjects at home, and they choose wisely.

And just here it can be said that if we are ever to have a school that will leave its impress on the art of the world, the task will be the easier if our men find their subjects at home— if they will show our own people the beauty, dignity, and grandeur of the material that lies under their very eyes, and also teach those fellows on the other side to respect us, both because we can paint and because we have the things to paint from. With a mountain and river scenery unrivalled on the globe; with rock-bound coasts breaking the full surge of an ocean; with forests of towering trees compared to which in girth and height the trees of all other lands are but toothpicks; with plains ending in films of blue haze and valleys sparkling with myriads of waterfalls; with every type of the human race blended in our own, or

distinct as are the woodman of Maine and the soft-eyed mulatto of Louisiana; with a history filled with traditions most romantic—Aztec, Indian, and negro; with women who move like Greek goddesses and children whose faces are divine, why go away from home to find something to paint? Winslow Homer never did, and that's why his work will live when the painters of Egyptian harems, Spanish dancers, and Dutch and Venetian boats and palaces are forgotten.

To take a specific example or two, what subject, for instance, is more worthy of a great master's brush than Homer's "Undertow," two half-drowned young bathers locked in each other's arms, the two beachmen dragging them clear of the mighty, blue-green wave curving behind them? Here is a subject of almost weekly occurrence on our coast. Who ever thought of painting it before? And that marvellous picture of "The Cotton Pickers." This, to me,

was the first clear note Homer had sounded. The "Prisoners to the Front," painted just after the war, was a strong, realistic picture, true and forceful in color and composition, and, of course, admirable in drawing, but that was all. It told its story at once, and having heard it to the end you acknowledged its truth and went away content. But "The Cotton Pickers" left something more in your mind. The gray dawn of the morning dimly lighted up a field of cotton, the negro quarters on the horizon line; dotted here and there, bending over the bolls, were groups of negroes, singly and in pairs, filling their bags; in the foreground walked two young negro girls, the foremost a dark mulatto—the whole story of Southern slavery written in every line of her patient, uncomplaining face.

This picture alone placed Homer in the first rank of American painters of his day, and he has never lost this place, for not only was the

picture all it should be in composition and mass, but, unlike many of Homer's pictures of an earlier period, it was deliciously gray and cool in tone. It places him also in the front rank of the painters of our time. Jules Breton never gave us anything more pleasing, and never anything stronger in drawing, more true to life, or more poetic in conception and treatment. I mention Breton because, of the men on the other side, he is the only one who affects, so to speak, a similar line of subjects. Breton loves his peasants and paints them as if he did. Homer loved his subjects entirely in the same spirit. How unequally the two men have been rewarded you all know. An all-wise American who some years ago offered $40,000 for a Breton at auction could not at the time have been induced to give one-tenth of that amount for a Homer; and yet, for vigor, truth, sentiment, and technic—yes, technic, for this picture was superbly painted—"The Cotton Pick-

ers," in my judgment, will outlive the other
if the time should ever come when picture-
buyers think for themselves.

The Englishman, on the other hand, is the
hardest man to pull out of a groove. What *has
been* is good enough for him, whether in archi-
tecture, art, politics, or government. Any one
who objects, or seeks to improve or to point
out a new and different way, is "anathema." It
is hardly more than twenty years ago that John
Sargent, whose works are often the strongest
drawing card in the annual exhibitions, was
ignored by the jury of the Royal Academy.

"A slap-dash sort of a painter, my dear boy.
Most dangerous to allow his things to come in.
No drawing, you know, no finish—altogether
out of the question." So spoke a Royal Acad-
emician when the question was broached.

Whistler never found a vacant spot, no mat-
ter how high, where he could hang even a
10 X 14.

Water-Colors

"A mountebank in paint, my dear sir. Think of giving him a place alongside of Sir Frederick Leighton! Impossible! Absolutely impossible!" That the Luxembourg exhibited his portrait of his mother, and that the art critics of Europe voted it "one of the greatest portraits of modern times," made no difference. These Royal wiseacres knew better. Some of them still think they know better, a fact easily ascertained when you walk through the Exhibition, as I do every summer, and have continued to do for the past thirty years.

And this adherence to tradition is not confined entirely to technic—I refer now to many of the English painters of to-day—but appears in their choice of subjects as well. It is the *subjects* which have been successful—that is, which have been *sold*—that must be painted over and over. Anything new is a departure, and a departure from the standard in the selection of a subject is as dangerous as a departure

in the cut of a coat or the color of one's gloves
—or was as dangerous until Sargent, Abbey,
Frank Brangwyn, and men of that ilk smashed
the current idols and taught men a new religion.
A small congregation, it is true, but big enough
for them to gather together to sing hymns of
praise and pray for better things.

Let me illustrate what I mean by conform-
ing to the standard. Three years ago I was
painting near a village, an hour from Padding-
ton—a lovely spot on the River Thames. This
quaint settlement is one of those little, wa-
terside, old-fashioned-inn places, all drooping
trees, punts, millions of roses, tumble-down
cottages, stretches of meadows with the silver
thread of the Thames glistening in the sun-
light. There is also a bridge, a wonderful old
brick bridge, stepping across on three arches,
mould-incrusted, blackened by time, masses
of green rushes clustered about its feet—a
most picturesque and lovable bridge, known

to about everybody who has ever visited that section of England.

I had been there for a week, making my headquarters at the White Hart, when my attention was attracted to a man across the river —it is quite narrow here—a painter, evidently, who seemed to be surrounded by a collection of canvases. He went through the same motions every day, and then my curiosity got the better of me and I went over to see him.

Spread out on the grass lay eight canvases, all of one size, and each one containing a picture of the old brick bridge.

᚜ "But why eight all alike?" I asked in astonishment.

"Because I can't sell anything else. I am known as the Sonning Bridge painter. I've been at it for twenty years."

It is with this sort of thing, either in the selection of a subject, in its treatment, or in its handling, that I have but little sympathy, even

though the great Ruskin, in speaking of this same English water-color school, the one I have catalogued for you, insists that it is the only "true school of landscape which has yet existed," an appreciation which is followed by the outburst that "from the last landscape of Tintoret, if we look for life we will pass at once to the first landscape of Turner." It is, of course, only one of Ruskin's dictatorial statements, admirable when written, because it was read and approved by a class who knew no better and who accepted his words as other blind devotees obeyed the Delphic Oracle— statements, however, which are rejected by many of to-day who think for themselves and who think clearly, having the world's work spread open before them from which to judge.

Once in wandering around the Accademia of Venice, taking in for the fiftieth time Titian's masterpiece, I came across an Englishman who had paused in his walk and was adjusting his

long-distance telescope—a monocle glued just
under his left eyebrow. Mistaking my red-
backed sketch-book for a Baedeker, he said,
in an apologetic tone:

"Pardon me—I've left mine at home—but
will you be good enough to tell me what Mr.
Ruskin says about that picture?"

That I have personally refused to follow
either Mr. Ruskin or the example of the men
he places on so high a pinnacle—I am now
referring entirely to their technic—is due to
my having painted all my life out-of-doors, the
best place in which a man can study nature at
close range. This experience has taught me
that weight and solidity are as important in the
rendering of a natural object as air and per-
spective, and that the *staining of paper with
washes of transparent color does not and can-
not give them.*

Nor can any brilliant light, a crisp, snapping

light—a glint of the sun's rays, for instance, on the break of the surf, or on the round of a glossy leaf, reflecting like a mirror the opaque sky— ever be achieved by careful working around the edges of an unwashed speck of paper— the transparent man's only means of expressing a high light.

Nor will a single dab of Chinese white produce the effect of it, should it be the *only* dab of opaque white in the composition. The result in this case is still worse, for if transparent color has any value when uniformly distributed it is in the expression of air and perspective. The dab, then, is instantly out of plane, as it comes nearer to the eye than the transparent wash about it, and the illusion of distance is accordingly lost.

But another and quite a different thing occurs when the opaque color *forms part* of the whole, the two systems blending each with the other. To illustrate, my own experience has

taught me that in nature whatever the sun shines *upon* is opaque. The façade of a cathedral, for instance, facing a sky where the rays of the sun strike it full is opaque, while the angles of the architecture, casting shadows large and small into which sink the blue reflections of the sky or the reflected lights from near-by objects, are invariably transparent.

And now for my own system and the reasons why I have abandoned all other systems. And in giving them to you I want to repeat what I said in the beginning of this course, that I do not ask you students to follow in my footsteps if your predilections, training, and innate consciences lead you to a different view of treatment. Many of you may not like my work at all, and you certainly have a large following, especially among the younger men and women who have advanced ideas. Many of you hold to the opinion that water-color men should

stick to their trade and not encroach upon the oil painters in their technic. And many of you may at heart prefer, nay, even delight in, the broad, loose washes of the early English school.

There may be a few of you, however, who have open minds free from prejudice and free from the traditions of the past, and who are dissatisfied with the want of "virility," if I may so express it, shown in pictures painted on white paper, and with successive washings, and may accordingly see something in my own methods which may encourage you to follow in the path which I have cleared and which I humbly trust will lead to infinitely better results than I have so far achieved.

And in this you must have the courage of your opinions and be prepared for criticisms. Those who are against me are more numerous than those who are for me and my methods.

Only last month a distinguished New York daily paper, in reviewing a recent exhibition, said:

Water-Colors

"There really is nothing left to say about Mr. Smith's water-colors. They appear with such unfailing regularity and are always so much the same. Nothing in the present collection will surprise those who know his work —and who does not? The artist's facility is undiminished, his industry untiring, but to look for any fresh inspiration in his work or a hint of anything but a conventional vision has long been a vain hope."

I should be discouraged if I thought that this was the last word on my work. I know better, because I am making a collection of such criticisms, showing the rating of our several painters. These summings up of mine will be extremely valuable as marking the changing taste of the public; for I have never supposed that either ill will or downright ignorance formed the basis of current criticism. The critics are merely expressing the trend of public opinion. It is not new to our age. Diaz, so

one story goes, once came stumping (he had lost one leg) into Millet's cottage at Barbizon fresh from the Salon. Millet had been painting nudes—the most exquisite bits of flesh-painting seen for many a day, and as modest as Chabas "September Morn."

"What do they say of my things?" asked Millet.

"That you are still painting naked women," replied Diaz.

Millet was horrified.

"I paint naked women! I never painted one in my life."

Hence "The Angelus" and "The Sowers" and the other masterpieces of clothed peasants.

In 1825 Constable writes in answer to a scurrilous attack made on his so-called "puerile" efforts:

"Remember the great were not made for me, nor was I for the great. My limited and abstractive art is to be found under every hedge

and in every lane, and therefore nobody thinks it worth while picking up. My art flatters nobody by imitation: it courts nobody by smoothness: it tickles nobody by politeness: it is without either fol-de-rol or fiddle-de-dee. How can I hope to be popular?"

Ruskin's attack on Whistler is another case in point. A lawsuit followed and Whistler recovered one farthing damages, and had the effrontery to dangle it under the great critic's nose that same night at a reception where they both met, followed by the remark:

"Beat you, old man."

Even Mr. Thackeray went out of his way in his "art notes" to belittle and ridicule Sir Thomas Lawrence because he lacked what he called the "virility of his progenitors and associates."

And now for my own system.

I use a heavy, gray charcoal paper, which is

Outdoor Sketching

made by Dupré & Company, No. 141 Fau-
bourg St. Honoré, Paris, and which costs about
ten cents per sheet, measuring about 40 x 30
inches each. This paper is evenly ribbed but
without the intermittent bands seen often in
the lighter charcoal paper, known as "Miche-
let," sold everywhere in our own art stores.
Dupré will send this paper to anybody who
applies for it.

This paper I wet on *both* sides and thumb-
tack over an oil canvas the size of the picture
to be painted. It dries tight as a drum, and
the canvas backing protects it from puncture
or other injury.

On this surface I make *a full and complete
drawing in charcoal* of the subject before me,
not in outline, but in strong darks, jet-black,
many of them—a finished drawing really, in
charcoal, which could be signed and framed.
This is then "fixed" by a spray of alcohol and
gum shellac, thrown by means of a common

perfume atomizer, the whole apparatus cost-
ing less than one American dollar.

On this I begin my color scheme in both
opaque and transparent color, recognizing the
"natural facts" already explained to you, that
is, the skies and high lights being solidly
opaque, the shadows being equally transparent.
This process requires certain modifications to
be made in the darks of the original drawing.
The dense black shadow under the eaves of a
roof, for instance, are not in nature as black
as the charcoal, but perhaps a rich, warm
brown. If the ground is in sunlight, it is a
dull, golden yellow and reflects the yellow glow
of the sand beneath. Or it may be a blue re-
flection, or even of a reddish tone. These hard
blacks then must be *glazed* in such a way as to
preserve the power of the shadow obtained by
means of the under charcoal, and yet keep it
transparent (all shadows being transparent) and
at the same time preserve its true and proper tint.

This glaze is done by using the three semi-opaque primary pigments—found in every color-box—namely:

> Light red,
> Cobalt-blue,
> Yellow ochre.

These colors, of course, form the basis of all intermediate tones, and from them all intermediate tones can be made.

These three colors are at the same time semi-opaque, their opacity being just sufficient to tint the hard black of the coal, while never clogging or muddying its transparency.

So it is with the millions of other tones in the whole composition, when such perfectly transparent colors as brown madder, Indian yellow, and indigo are used as a glaze, altering and modifying the undertone of charcoal to any desired tint and at the same time preserving the all-important thing—its transparency.

In conclusion, let me say that I fully recognize that I am addressing students whose training enables them to understand perfectly this explanation, and that further instructions are therefore unnecessary.

One thing, however, may be accentuated, and that is the use of plenty of clean water. Another is that you should keep your palettes separate. For myself, I make use of a common white metallic dinner-plate, known as iron-stone china, costing another ten cents, for my sky-palette, squeezing the color-tubes in a row around its edge and my Chinese white below them on one side toward the bottom. For my transparent palette, I use an ordinary moist sixteen-pan color-box, being always careful never to blur it with even a brush stroke of body color (Chinese white); and for my opaque work, an oval white metal palette, with thumb-hole, and indentations around its edge into which I squeeze the contents of my moist water-color

tubes, my Chinese white being heaped up in a little mound near my thumb.

The result may be seen in some of the illustrations accompanying this text.

CHARCOAL

CHARCOAL

BEFORE going into the value of charcoal as a medium in the recording of the various aspects of nature in black-and-white, it will be wise to review the several mediums in general use, namely, etching, pen and ink, lithographic crayon, and charcoal gray in connection with Chinese white; it will be well, also, to note the various mechanical processes in use for the reproductions of these drawings on white paper.

Those of you who have seen the early illustration in *Harper's Magazine* of the late fifties will recall the work of "Porte Crayon" (Colonel Strother), drawn on wood by the artist and engraved by such men as A. V. S. Anthony and John Sartain. You will also recall how some twenty-five years later an effective and

marvellous change took place in the quality of these reproductions, being by far the most unique and rapid in the history of any art of the century. In less than ten years, between 1876 and 1886, came this sudden awakening to the necessity of better work from the burin, followed by an enormous commercial demand for such results, until by common consent the American engraver first rivalled and then surpassed the world. If we search for the cause we find that, like many other inventions developing others of still greater importance, as the telegraph developed the telephone, electric light, and the phonograph, this marvellous change is due entirely to the discovery and possibility of photographing direct from the original upon the boxwood itself, producing with an instant's exposure a complete reproduction of the original drawing, with all its texture, gradation, and quality, not only doing away entirely with the intermediate

draftsman, as was the case with "Porte Cray-on's" work, but obtaining a result impossible to the most skilful of the artists on wood of his day.

Another important feature in the discovery was the possibility of reducing a drawing to any size required, thus fitting it exactly to the necessities of the printed page. Before these discoveries, as you well know, from the time of Albert Dürer down to Linton and engravers of his school, the original drawing of the painter was redrawn by the use of lead-pencil, Chinese white, and India-ink washes upon the wood itself, giving as close an imitation as possible of the original. Some painters—illustrators, if you please, in those early days—in fact, made their original designs direct upon the wood. The effects of light and dark were then cut out in lines, curved or otherwise, with suitable cross-hatchings, as the necessity of the draw-ing required, or left comparatively untouched.

Outdoor Sketching

It is not my purpose to discuss here the different merits of the different schools. There are varieties of opinion regarding the excellence of the line compared with the technic in the modern school of engravers. By the modern school I mean the work of such men as Cole, Yuengling, Wolff, French, Smithwick, and others. I refer to them that I may accent the stronger the medium which is the subject-matter of this talk, namely, charcoal, in the hope that those of you who propose to make reproductive illustrations your life-work may be tempted to make use of charcoal as a medium through which to express your ideas and ideals.

But before embarking on this phase of my subject it may be interesting for a moment to go a little deeper into the earlier stages of this marvellous change from boxwood to zinc. I remember distinctly the beginnings of an organization well known in New York, and perhaps to many of you, as the Tile Club, to which

organization I can conscientiously say as much credit is due for this revival in wood-engraving as to any other. Not that good wood-engravers did not exist before its time, and not because it contained wood-engravers, for the club did not have the name of one among its membership, but as containing a group of painters who for the first time in aid of the art of wood-engraving in this country lent their names and brushes to an illustrated magazine. Up to that time there had been a wide gulf existing between the ordinary draftsman on wood and a painter. This did not proceed from the prevalence of a certain disease among the painters, known at the present time as an "enlarged head," but from the fact that no artist accustomed to free-hand drawing and at liberty to wander all over his canvas at will would bring himself down to working through a magnifying-glass, a necessity, often, in transferring a drawing to wood.

Outdoor Sketching

With this discovery, however, of making
available even the roughest drawing, the sim-
plest blot in color or a scratch in charcoal, and
photographing its exact *textures* upon a wooden
block, the camera reducing it in size and thus
perfecting it, the artist immediately took the
place of the draftsman, and at the same time
introduced into the work an artistic quality, a
dash, a vim and spirit entirely unknown before.

Three things were needed to utilize this
marvellously useful discovery: first, a painter
of rank; second, an engraver who could express
the textures and technics of the several art-
ists—that is, reproduce the exact values of an
original in wash, an original in charcoal, or an
original in oil; and third, a magazine with
sufficient capital, taste, and intelligence to
reproduce these results upon a printed page.
We had the painters, and the engravers de-
veloped rapidly. The third requirement, of
taste and intelligence, was found in Mr. A. W.,

Charcoal

Drake, then art director of *Scribner's Monthly*,
and, after its merging into the *Century*, the distinguished art director of the *Century Magazine*.

When the Tile Club was formed in New York
it consisted of a group of men (I was its scullion
for seven years, its entire life, and, being thus
an honored servant, was familiar with its many
affairs) who represented at the time the leading spirits of the different schools: William M.
Chase, Arthur Quartley, Swain Gifford, A. B.
Frost, George Maynard, Frank D. Millet, Alden
Weir, Edwin A. Abbey, Charles S. Reinhart,
Elihu Vedder, William Gedney Bunce, Stanford
White, Augustus Saint-Gaudens, and one or two
others. The club was limited to eighteen members, there being twelve painters and six musicians. If I am not very much mistaken, not a
single painter of this group had ever drawn upon
a wooden block, and yet each one of them, as
the records of our periodicals have shown, was
admirably qualified for illustrative work. At

the time, the illustrations in *Harper's* and *Scribner's*, compared with the illustrations of to-day, reminded one of the early primers of the New England schools, with their improbable trees and impossible animals.

I remember distinctly the first meeting of the Tile Club, in which the subject of drawing for *Scribner's Monthly* was first mooted, and I do not believe I overestimate the importance that the position of the club, taken at that time, has had and still has—not as a club, for it was dissolved some years back—in the influence its personal art has wielded upon the printed pages of the day.

The first magazine article was the account of a trip that we made down on Long Island, illustrated by the club, entitled "The Tile Club Abroad," each man choosing his own medium —oil, charcoal, water-color, etc.; the results of which were published in the then *Scribner's Magazine*, and engraved by a group of men

who afterward placed the art of wood-engraving in America side by side with the best efforts ever obtained by the English and German periodicals, and one of whom, Yuengling, took the gold medal of excellence both in Paris and Munich.

With this difference in textures, the difference between a drawing in charcoal and one made in oil, it became necessary to invent new modes of expression with the burin. A simple line which might express the round of the cheek or the fulness of the arm, and which would answer for the uniform drapery of the old school, would not serve to explain the subtle quality of one of Quartley's moonrises or the vigor and dash of one of Chase's outdoor figures sketched in oil.

So it came about that in searching to express these new qualities, never before seen upon a block, the technic of the new school was developed.

Outdoor Sketching

The next important result was the creating
not only of a new school of wood-engraving,
but of an entirely distinct department for art
workers, the school of the illustrator; and so
we have Abbey, Reinhart, Quartley, and, later,
Church, Smedley, Dana Gibson, and dozens
of others whose names will readily come to
your minds and of whose careers I have already
spoken.

But the burin was too slow, even in the hands
of the skilful engraver, for the necessities of
the hour. It was also too expensive; a drawing
which a magazine would pay the artist $50 for
would often cost $200 to engrave in the hands of
a master like Yuengling or Cole. Again pho-
tography was called into use. The "straight
process," so called, of the phototype printer, re-
producing a pen-and-ink line drawing on a zinc
plate which could be immediately run through
a Hoe process, was perfected. You all remem-
ber, doubtless, an illustrated daily published

in New York, called *The Daily Graphic*, illustrated by this process. This process, however, was only possible where pen-and-ink drawing or a very coarse lead-pencil drawing was used in making the original, because it was necessary that spaces of white should exist between each separate line or mass of black. This process, however, utterly failed in all India-ink drawings. Where these drawings covered the white of the paper, if ever so delicately, the result was a dense black upon the plate.

Then came a race between all the inventors interested in such discoveries, both here and abroad—a race to perfect a process which would produce from such wash drawings an exact reproduction upon the printed page, giving all the gradations of the original and doing away not only with the draftsman but with the wood-engraver. To Professor Vogel, of Berlin, I believe—although an American, Ives, claims it, and some say justly—is due

the credit of perfecting what is known as the half-tone, or screen process: many others claim that Herr Meisenbach first perfected this most important discovery.

As the wash drawing had no lines, and as it is absolutely necessary that photo-printing should have lines—that is, clean spaces of black between white—these lines were supplied by laying a sheet of plate glass over the drawing upon which the lines were cut by a diamond and through which the original could be clearly seen. Of course, the light falling upon the edges of these several diamond cuttings made little points of brilliant white between which the several blacks and whites could be seen. This, without going very much further into the mechanical details, is the basis of the half-tone process.

While this had its value, it had also its demerits, one of which was the total extermination of the American wood-engraver, except for

a few men like Timothy Cole, whose genius and skill made it possible for them, by the excellence of their work, to survive the great difference between twenty cents a square inch for transferring on zinc and twenty dollars a square inch for engraving on wood.

There are, however, results in the half-tone process which I hold are infinitely superior to the work of any wood-engraver of the old school. While it is true that there is no really positive rich dark for any part of the composition—for, of course, the light specks are everywhere, thus lightening and graying the dark—and while we lose by such defects the richness of wood-engraving, we also get the exact touch of the artist in no more and no less a degree, particularly no less. How often have I seen an exquisite drawing of Abbey's or Du Maurier's almost ruined by the slipping of the burin the one-thousandth part of an inch! How infinitely superior are the originals of John

Outdoor Sketching

Leech's immortal caricatures in *Punch* to the reproductions, all because the shadow line under an eye, or that little dot which denotes the difference between amusement and curiosity in the expression of a face, has been cut away the thousandth part of a hair-line! The processes of the half-tone, however, are ever accurate and the reproduction given you is exact—with the foregoing restrictions.

Then again, in landscape effects and in some portraits, the uniformity of tone, the certainty of every touch being reproduced, the exact balancing from dark to light, all result in better work than can be done by the ordinary engraver.

And yet, with all the half-tone's advantages, I must admit that Yuengling's head of the "Professor" and many of his wood-cuts in an illustrated edition of "Sir Launfal," published some years ago, and much of the work of such masters as Cole, Wolff, Yuengling, and others,

stand as monuments for all time to the skill
of hands that no process will ever excel, for
they put into it that something which the bath
of vitriol will never furnish, a bite of the acid
of their own genius.

Since these earlier days a new departure has
been made, until now reproductive processes
have been brought to such perfection that there
is hardly any texture or color scheme that can-
not be matched. Note, if you will, Howard
Pyle in color—rich in⸍ yellows and reds, with
black and white spaces as an enrichment. Note
also A. I. Keller's transparent work in charcoal
gray. Note particularly the reproductions in
the magazines of F. Walter Taylor's drawings
in charcoal, in which the very texture of the
coal is preserved. And, if you will permit me,
note the half tones of my own charcoal draw-
ings now on exhibition in the adjoining gallery.
So perfect is the reproduction that one is care-
ful not to smudge his fingers in turning the

leaves of the publication in which they are printed.

This being the case (and the printers must be thanked as well for their share in the results), I earnestly hope that some of my brother illustrators—the more the merrier—will seriously consider the value of charcoal as a medium for illustrative work. There is no subject, I assure you, that the sun shines on or its light filters into, or any phase of nature, be it rain or storm, fog, snow, or mist, including marines, figures, sunrises and sunsets, blazing heat and cool, transparent shadows, that cannot be visualized by it.

I hold, too, that by its use qualities can be obtained impossible to be found in either etchings, lithographic crayon, wash, or pen and ink—especially the velvet of its black.

Charcoal is the unhampered, the free, the personal individual medium. No water, no oil, no palette, no squeezing of tubes or wip-

ing of tints; no scraping, scumbling, or other dilatory and exasperating necessities. Just a piece of coal, the size of a cigarette, held flat between the thumb and the forefinger, a sheet of paper, and then "let go." Yes, one thing more—care must be taken to have this forefinger fastened to a sure, knowing, and fearless hand, worked by an arm which plays easily and loosely in a ball-socket set firmly near your backbone. To carry out the metaphor, the steam of your enthusiasm, kept in working order by the safety-valve of your experience, and regulated by the ball-governor of your art knowledge—such as composition, drawing, mass, light and dark—is then turned on.

Now you can "let go," and in the fullest sense, or you will never arrive. My own experience has taught me that if an outdoor charcoal sketch, covering and containing all a man can see—and he should neither record nor explain anything more—is not completely fin-

ished in two hours it cannot be finished by the same man in two days or two years.

For a drawing in charcoal is really a record of a man's temperament. It represents pre-eminently the personality of the individual—his buoyancy, his perfect health, the quickness of his gestures. All these are shown in the way he strikes his canvas—compelling it to talk back to him. So also does it record the man's timidity, his want of confidence in himself, his fear of spoiling what he has already done, forgetting that a nickel will buy him another sheet of paper.

Courage, too, is a component part—not to be afraid to strike hard and fast, belaboring the canvas as a pugilist belabors an opponent, beating nature into shape.

As for the potterer and the niggler, the men and women whose stroke goes no farther back than their knuckles, I may frankly say that charcoal is not for them. The blow is a sledge

The George and Vulture Inn, London

blow going from the spinal column, not the pitapat of a jeweller's hammer elaborating the repoussé around a goblet.

Remember, too, that the fight is all over in two hours—three at the outside—the battle really won or lost in the first ten minutes, if you only knew it: when you get in your first strokes, really defining your composition and planting your big high light and your big dark. It is all right after that. You can taper off on the little lights and darks, saving your wind, so to speak, sparring for your next supplementary light and dark.

Remember, too, that when the fight is over you must not spoil what you have done by repetition or finish. *Let it alone.* You may not have covered everything you wanted to express, but if you have smashed in the salient features, the details will look out at you when you least expect it. There are a thousand cross lights and untold mysteries in Rembrandt's

shadows which his friends failed to see when his canvas left his studio. It is the unexpressed which is often most interesting. Meissonier tells his story to the end. So do Vibert, Rico, and the whole realistic school. Corot gives you a mass of foliage, no single leaf expressed, but beneath it lurk great, cavernous shadows in which nymphs and satyrs play hide-and-seek.

Remember, also, that just as the blunt end of a bit of charcoal is many, many times larger than the point of an etching-needle, so are its resources for fine lines and minute dots and scratches just that much reduced. It is the flat of the piece of coal that is valuable, not its point.

As to what can be done with this piece of coal, I can but repeat, *everything*. That there are some subjects better than others, I will admit. For me, London, its streets and buildings, come first, especially if it be raining; and

there is no question that it does rain once in a while in London, making the wet streets and sidewalks glisten under its silver-gray sky, little rivulets of molten silver escaping everywhere. When with these you get a background—and I always do—of flat masses of quaint buildings, all detail lost in the haze and mist of smoke, your delight rises to enthusiasm. Nowhere else in the world are the "values" so marvellously preserved. You start your foreground with, say, a figure, or an umbrella, or a cab, expressed in a stroke of jet-black, and the perspective instantly fades into grays of steeple, dome, or roof, so delicate and vapory that there is hardly a shade of difference between earth and sky. Or you stroll into some old church or cathedral, as I did last summer when I found myself in that most wonderful of all English churches—and I say it deliberately—St. Bartholomew's the Great, over in Smithfield.

Other churches have I studied in my wan-

derings; many and various cathedrals, basilicas, and mosques have delighted me. I know the color and the value of tapestry and rich hangings; of mosaics, porphyry, and verd-antiques; of fluted alabaster and the delicate tracery of the arabesque; but the velvety quality of London soot when applied to the rough surfaces of rudely chiselled stones, and the soft loveliness gained by grime and smoke, came to me as a revelation.

This rich black which, like a tropical fungus, grows and spreads through St. Bartholomew's interior, hiding under its soft, caressing touch the rough angles and insistent edges of the Norman, is what the bloom is to the grape, what the dark purpling is to the plum, mellowing from sight the brilliancy of the under skin. And there are wide coverings of it, too, in this wonderful church, as if some master decorator had wielded a great coal and at one sweep of his hand had rubbed its glorious black into

every crevice, crack, and cranny of wall, column, and arch.

Certain it is that no other medium than the one used could give any idea of its charm. Neither oil, water-color, nor pastel will transmit it—no, nor the dry-point or bitten plate. The soot of centuries, the fogs of countless Novembers, the smoke of a thousand firesides were the pigments which the Master Painter set upon his palette in the task of giving us one exquisitely beautiful interior wholly in black-and-white.

So it was in the Temple when I was searching for Mr. Thackeray's haunts.

What of alterations, scrapings, patchings up, and fillings in have taken place in these various courts and their surroundings, I did not trouble myself to find out. Nothing looks new in London after the fogs and soot of one winter have wreaked their vengeance upon it. Whether the façade is of brick, stone, or stucco depends

entirely on the thickness of the soot, packed in or scoured clean by winds and rains, or whether the surface is ebony or marble, as may be seen in many of the statues on Burlington House, where a head, arm, or part of a pedestal chair has been kept white by constant douches.

As for me, I was glad that these old haunts of Mr. Thackeray and his characters are even blacker to-day than they might have been in his time. For the soot and grime become them, and London as well, for that matter. A great impressionist, this smoke-smudger and wiper-out of detail, this believer in masses and simple surfaces, this destroyer of gingerbread ornaments, petty mouldings, and cheap flutings!

And now for a few practical data as to my own way of handling the coal. which may be of value as coming from one who has profited these many years by its infinite possibilities.

The above cleaned spots
are obtained by use of
ductile rubber

Diagram of Charcoal Technic

Charcoal

The paper is the same I use in my water-colors, a delicate, gray, double-thick charcoal paper, laid in parallel ribs, if I may so express it, and having sufficient body and tooth to catch and hold the faintest touch or the strongest stroke of the coal. The gray of this paper serves as the middle tone of the drawing, the different gradations of black in the coal giving the darks and the careful use of white chalks the high lights.

These gradations are obtained by the use of a few simple processes, by which various textures can be given, starting, for instance, from or near the foreground, where the grit of the charcoal is used to bring the nearer details into clear relief, the several larger gradations and textures giving aerial perspectives being produced by a broad sweep of the hand, forcing the grit of the coal into the crevices of the paper, the result being what I may term the *first* plane or *nearest* atmospheric value; the

house a square away, if you please—provided the subject is a street—being the *second* plane.

Beyond this, farther down the street, is found, it may be, another house or other object. Now try your thumb, rubbing your hand-smoothed charcoal into a finer and closer mesh: and for the still more atmospheric distances down this same street, use next a rag, then a buckskin stomp, and last of all a stiff paper stomp, each in turn producing a more atmospheric gray as the distances fade—the last, the paper stomp, being as soft as a wash of India ink. (See diagram.)

All these you may say are tricks. They are —my own tricks, or rather use of the means which lay at my hand, which long experience has taught me to employ, and which any one of you will no doubt better in your own handling of the coal.

These planes being secured, any light higher than the prevailing rubbed-in tone can be

Charcoal

wiped out clean to the grain of the paper by a piece of ductile rubber. Any darker dark, of course, can be obtained by retouching with the coal.

The chalk now comes into play for skies, broad sunlight effects, or crisp, sparkling lights. The whole work is then "fixed," as I have already explained, by the use of gum shellac and a common perfume atomizer.

And with this condensed statement I must bring this my last talk to a close, remembering as I do that I have been addressing a body of students who are already familiar with one or more mediums, and who, with these few spoken memoranda and a finished drawing before them, will solve at a glance mysteries baffling to the layman.

Lightning Source UK Ltd.
Milton Keynes UK
UKHW022147040820
367710UK00006B/139

9 781359 754103